GUSTAV KLIMT

THE LIFE AND WORKS OF

KLIMT

Nathaniel Harris

A Compilation of Works from the
BRIDGEMAN ART LIBRARY

PARRAGON

Klimt

This edition first published in Great Britain in 1994
by Parragon Book Service Limited

© 1994 Parragon Book Service Limited

ISBN 1 85813 501 X

Printed in Italy

Editorial Director: Lesley McOwan
Designer: Robert Mathias
Production Director: David Manson

Gustav Klimt 1862-1918

Gustav Klimt's life coincided with the golden age of turn-of-the-century Vienna, which was still the capital of a large empire. Apart from Klimt himself, Sigmund Freud, Gustav Mahler and Arnold Schoenberg were all Viennese. Though Klimt dominated the artistic scene, he had many distinguished colleagues including Koloman Moser, the architects Josef Hoffmann and Josef Maria Olbrich and, of the younger generation, Egon Schiele and Oskar Kokoschka.

This was an age of artistic renewal and revolt, when 'modernism' was born. It was also the age of art nouveau, and of self-consciously 'decadent' attitudes in art and literature, shot through with powerful and often morbid erotic obsessions. Nowhere were the tensions of the period more strongly felt than in Freud's Vienna, where Victorian morality still ruled on the surface while recklessly taken pleasures were the order of the day at most levels of society.

In Klimt, Viennese sexuality found its greatest poet. No other artist of his stature has been so openly devoted to the celebration of Eros, and above all of woman as muse, vamp, sexual object and ultimate fulfilment. At the same time, Klimt's art was enriched by the struggle between contrary impulses – the sensuous, essentially naturalistic depiction of eroticism, and an almost overmastering urge to fill the canvas with brilliant, intricate decoration. The

tension between the two is found even in Klimt's superb portraits of society women and in his dazzling, underrated landscapes. In his most celebrated works, such as *The Kiss* (page 59), emotion and decorative extravagance fuse in unsurpassed fashion.

Klimt was born in the Viennese suburb of Baumgarten on 14 July 1862. His father, an immigrant from Bohemia, failed to prosper at his trade as a gold engraver, and the Klimt children were brought up in poverty. Gustav left school at 14, but he managed to enrol at a college of art and craft. His did so well that he was working on commissions even before leaving the college, forming a partnership with his brother Ernst and another artist, Franz Matsch.

Subsequently the Klimt-Matsch firm was entrusted with ever more important tasks as decorators of the great new public buildings being constructed in the 1880s and 1890s. By his mid-30s Klimt was recognized as an outstanding painter-decorator in the glossy orthodox style of the period, with a career of lucrative official commissions apparently before him. However, in 1897 he took part in a rebellion against the art establishment that led to the founding of the Secession – a breakaway group of artists who wanted to create and exhibit work in more modern and adventurous styles.

Klimt became the Secession's first president, but he was still regarded as a reliable decorative artist – until 1900, when he showed the first of the pictures he had been commissioned to paint for the ceiling of Vienna University's Great Hall. In *Philosophy,* and later *Medicine* and *Jurisprudence,* Klimt created a devastating vision of the human condition, replete with pain, sex and death, that provoked a storm of criticism. Finally, in 1905, Klimt

borrowed the money to repay his advances on the paintings and repossessed them.

Fortunately he was so much in demand as a portraitist that he was always able to make a comfortable living and, free from the burden of official commissions, could go his own way. In reality Klimt was anything but a rebel by choice, shunning publicity, following a routine of hard, regular work, and keeping any turbulent moments in his private life very much to himself. The story of his life is that of his artistic development, which went on, seemingly uninfluenced by the outbreak of a World War in 1914, reflecting an interior world of vivid colour and sensuality.

On 11 January 1918 Klimt suffered a stroke which paralysed his right side, and hopes for his recovery faded when he contracted pneumonia. He died in Vienna on 6 February, a few months before the complete collapse of Austria-Hungary and the world he had known.

▷ **Fable** 1883

Oil on canvas

PAINTED WHEN KLIMT was only 21, *Fable* is already the work of an accomplished artist, though it contains no hint of his extraordinary future development. In this year, Gustav Klimt, his brother Ernst and their fellow-student Franz Matsch had become successful enough to set up their own studio in Vienna's Sandwirthgasse, tackling a range of joint projects. However, *Fable* was commissioned specifically from Gustav. The nude female figure holds a pen and has a rolled-up sheet of paper close to her, but whether that makes her a writer of fables seems dubious – especially since the animals around her represent creatures in the fables of Aesop, traditionally held to have been a (male) Greek slave. One group represents the lion who spared a mouse and was repaid when the mouse nibbled away the netting in which he was trapped; the other shows the storks playing a tit-for-tat revenge on the fox, who is confronted with a dinner which he cannot get at and must leave to the long beaks of the birds.

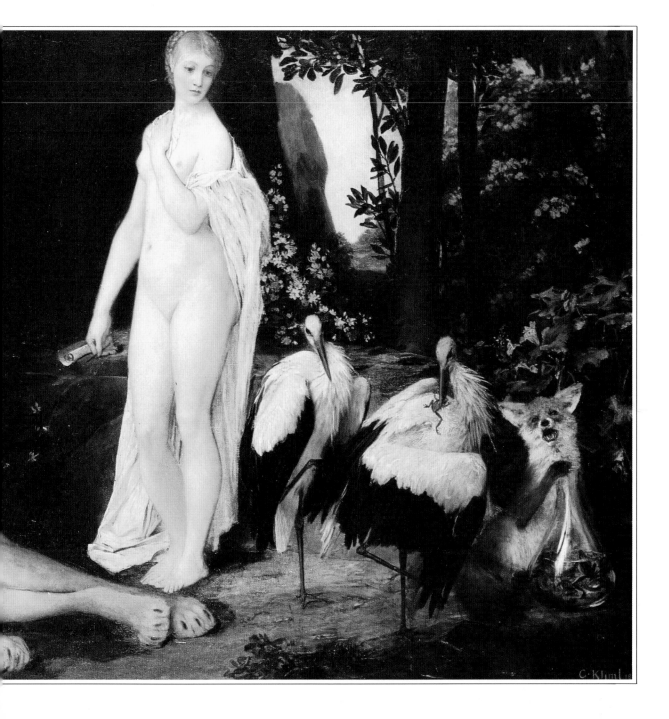

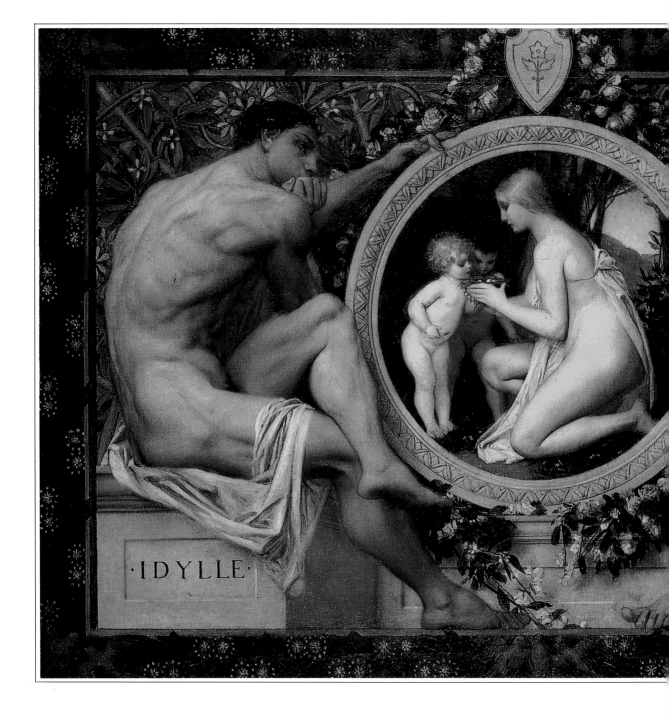

·IDYLLE·

◁ **Idyll** 1884

Oil on canvas

Idyll, LIKE FABLE, was one of a series of illustrations commissioned from Klimt as early as 1881, when he was still a student. The publisher Martin Gerlach conceived the idea of creating a luxurious set of *Allegories and Emblems,* in which promising or leading artists should illustrate various abstract conceptions. The flavour of the collection can be gathered from the titles of other works which Klimt executed for it, including *The Four Seasons, The Times of Day* and *Youth.* Most of Klimt's income at this time came from the decoration of buildings, and *Idyll* has a distinct resemblance to a painted panel meant for a wall. The male figures seem to have been directly inspired by Michelangelo; nothing like this would be seen in Klimt's mature work. The 'classical' look of the painting was very much to the taste of the time.

▷ **Auditorium of the Old Burgtheater** 1888

Gouache on paper

As A YOUNG ARTIST, Klimt was fortunate in living at a time when there was a building boom in Vienna. He and his partner Franz Matsch were in great demand as decorators, and they even benefited from the scheduled demolition of the old Burgtheater, which they were asked to commemorate in paintings. In Vienna the theatre was a great social institution, and Klimt chose to show the auditorium filled with wealthy and elegant people. The picture is not large, but thanks to Klimt's skill as a portraitist almost every face in the crowd was recognizable. Klimt's scheme made him a celebrity, since everyone of any standing in Vienna was desperately anxious to be included in the scene, and consequently the painter's studio was besieged. When completed, the picture included well over 100 portraits, a *tour de force* recognized in 1890 when Klimt was awarded the Emperor's Prize.

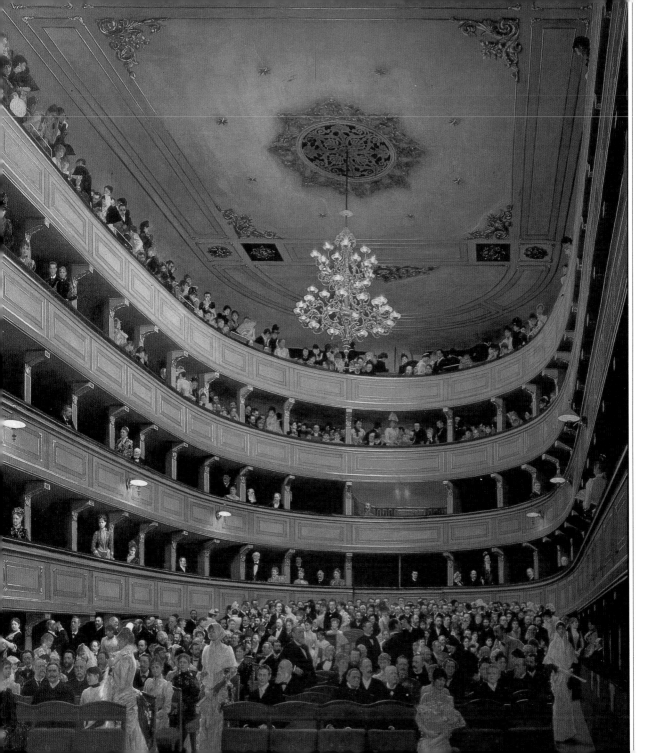

Detail

▷ **Theatre in Taormina** 1888

Oil on canvas

KLIMT RECORDED Vienna's old Burgtheater (pages 12-13) before it was demolished, and he and his partners were also involved in the decoration of the theatre that replaced it. They were commissioned to paint the ceilings over the two main staircases with historical scenes connected with the theatre. This job was notably different from the deeply personal works of Klimt's maturity, even though contemporaries had a high opinion of the artistic results: the subjects were not chosen by the artists, whose workmanlike attitude to the project can be gauged from the fact that they drew lots to decide which areas each should paint! Between 1886 and 1888 Klimt completed *The Chariot of Thespis, The Globe in London, The Altar of Dionysus, The Altar of Apollo* and *The Theatre of Taormina.* Artists were expected to study hard to make history paintings of this kind accurate in all their details. The result, here and elsewhere, often had a distinct period charm – but the period was always the 19th century, albeit sunk in voluptuous dreams of Antiquity.

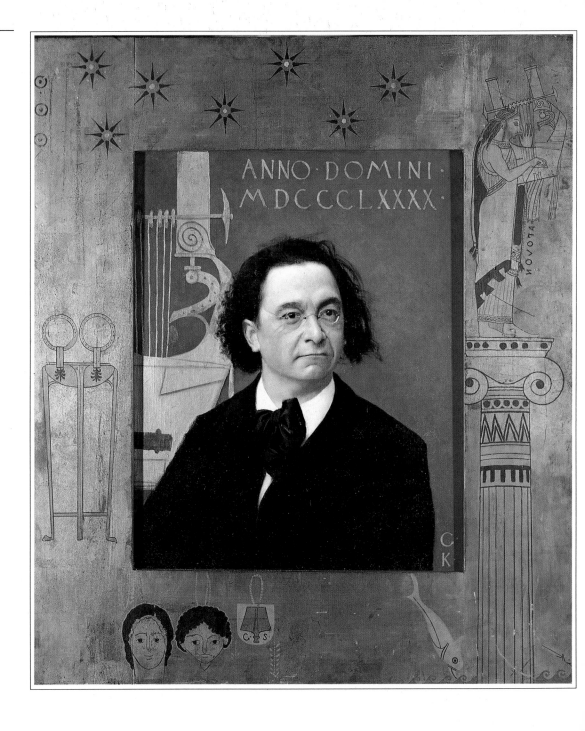

◁ **Portrait of Joseph Pembauer** 1890

Oil on canvas

THIS IS ONE of the earliest works by Klimt to convey something of his special quality, a combination of naturalistic portraiture and stylized decoration that was new to European art. As a student, Klimt had earned money by painting portraits from photographs, a more demanding practice than conventional portraiture executed from a model. Klimt could capture a likeness with 'photographic' accuracy which stood him in good stead when he made a group portrait out of *The Auditorium of the Old Burgtheater* (pages 12-13). Here, the pianist Joseph Pembauer, with his unkempt hair and lined, intent face, is almost unnervingly present. The red background and golden lyre, though restrained by Klimt's later standards, contrast strongly with the figure of Pembauer. The embossed copper frame is even more daring, with its wealth of classical motifs.

▷ **Love** 1895

Oil on canvas

KLIMT'S FATHER and his brother Ernst died in 1892, and soon afterwards his partnership with Franz Matsch broke up. For several years he seems to have produced very little, perhaps because he was beginning to be dissatisfied with an art that was much-praised, skilful but conventional. But he did undertake commissions for a follow-up to the first series of *Allegories and Emblems,* which had enjoyed a considerable vogue. *Love* appears to be a sentimental celebration of romance, with the girl almost swooning as her lover stoops to kiss her. Klimt was certainly providing acceptable fare which contrasts ludicrously with his sex-saturated work only a few years later. However, the figures hovering above the lovers introduce a more sinister note, and in traditional fashion the full-blown roses suggest the brevity of youth and love. The frame-like gilded panels give an impression of substance to this rather slight work.

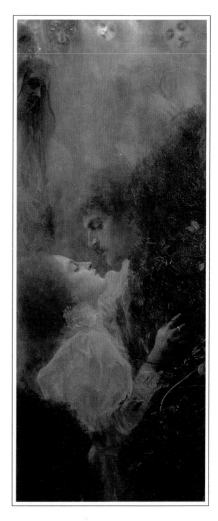

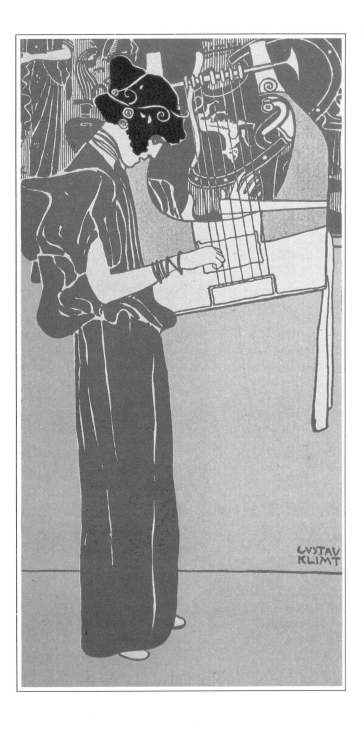

◁ **Music 1901**

Lithograph

THOUGH PRIMARILY a painter, Klimt published drawings and occasionally experimented with other media. *Music* is a lithograph; the technique, widely used for posters, involved drawing on to a stone with special crayons and printing, one colour at a time, on to paper. Lithographs give large, strong effects which are, as here, very striking, although not of a kind usually characteristic of Klimt's art. The same lyre-playing Greek maiden, accompanied by a sphinx and other Symbolist elements, appeared in an earlier, now destroyed painting, *Music I* (1895), where the lyre is transformed into an instrument of shining gold, a medium whose use was to become one of Klimt's hallmarks.

▷ **Tragedy** 1897

Mixed media

Tragedy, LIKE *Love* (page 17), was produced for the second series of *Allegories and Emblems,* which appeared between 1896 and 1900. It is not a painting but an immensely skilful drawing, done with black chalk and pencil, heightened with gold and white. The first tragedies were written and performed in ancient Greece, where the actors – all men – wore masks. Klimt's 'actor' appears to have taken off the mask a few moments ago, revealing its possessor as a woman – and, perhaps even more significant, one with a face that is as sombre and fearful in its own fashion as the tragic shell that concealed it. *Tragedy* shows Klimt beginning to find his own style, though it is still strongly influenced by Symbolism; the border decorations have an interesting resemblance to the spiky, sinister creations of the British illustrator Arthur Rackham, best known for his children 's books.

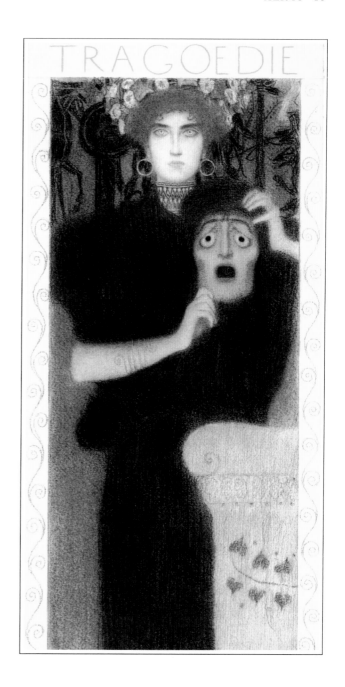

▷ **Flowing Water** 1898

Oil on canvas

BY 1898 KLIMT had broken with the Viennese establishment by heading the new Secession group of artists, though he was still a thoroughly respectable figure. But in *Flowing Water* he revealed himself as the master of an erotic art that would never be fully accepted in his lifetime. In this picture, the long lines of moving water, the trailing hair and long, outstretched limbs combine to create a sense of universal flow, beyond thought or purpose. The women, with their unconcealed nakedness, are carried along in a watery, sensual dream that might have been devised as an illustration of psychoanalytical theories of sexuality and the unconscious mind; the comparison is not frivolous, since Sigmund Freud was formulating his epoch-making theories at this very time, publishing *The Interpretation of Dreams* in the following year. Klimt incorporated several figures from *Flowing Water* in his controversial paintings for the University Great Hall (page 30).

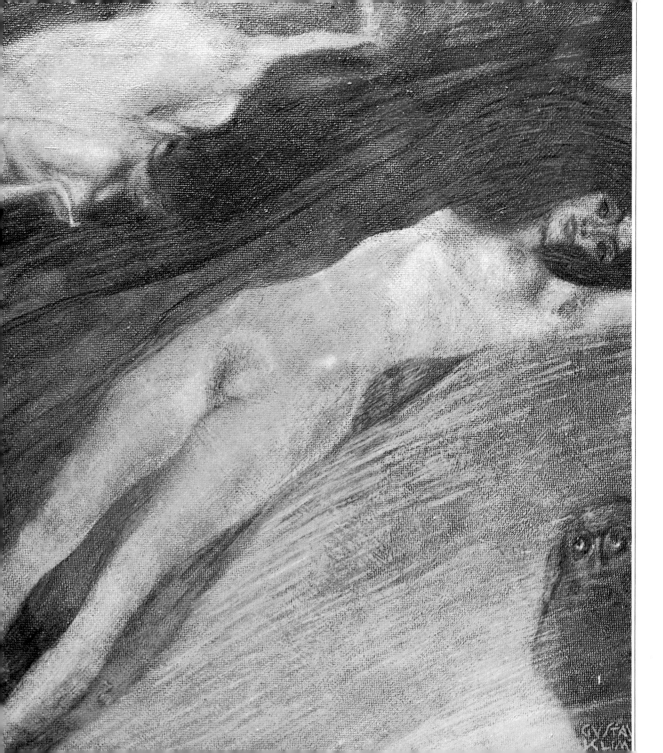

Detail

▷ **Pallas Athene** 1898

Oil on canvas

KLIMT BASED THIS PICTURE on one of the panels he had painted for Vienna's new Kunsthistorisches Museum in 1890-1, when he was still working as a mural painter. In 1897 the Secession, a breakaway artistic organization, had been formed with Klimt as its president, and had taken Pallas Athene as its symbolic protector. Here she is splendidly clad in a helmet and a mail breastplate with a gorgon's head device on it; the protruding tongue could be construed as a response to the Secession's critics. In her right hand the goddess holds a small figure of Nike (Victory). The scene behind Athene is taken from a Greek vase in the black-figure technique, showing two figures wrestling. As in a number of Klimt's works, the frame is an integral part of the composition; his brother Georg, a skilled craftsman in metal, made it to Klimt's design.

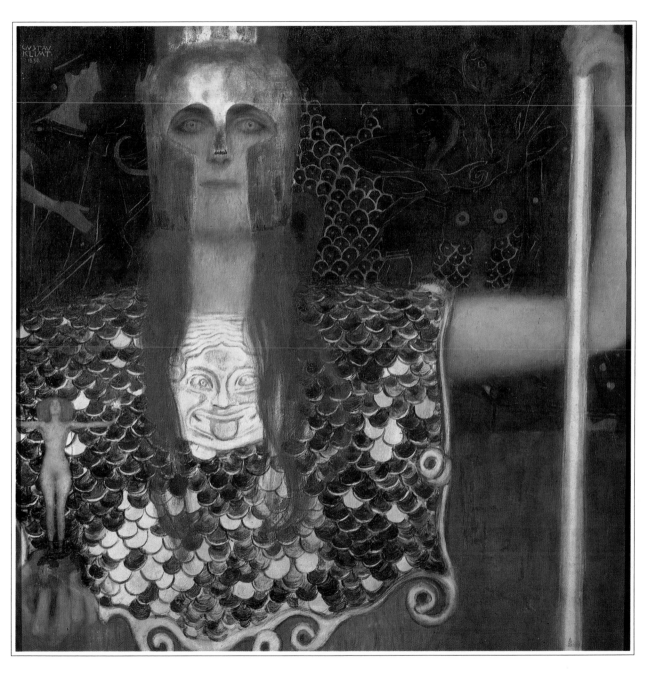

▷ **Portrait of Sonja Knips** 1898

Oil on canvas

ONE OF THE SEVEN pictures shown by Klimt at the second Secession Exhibition (1898-9), this is at first sight a fairly conventional work. The woman's elegantly posed, slender figure and the soft, feathery treatment of her dress create a flattering effect worthy of a professional portraitist. From this time onwards Klimt did in fact make much of his income from female portraiture, but his patrons proved surprisingly responsive to his increasingly unorthodox work. This painting, with its square format and diagonal division, anticipates the greater audacities of the portraits of *Fritza Riedler* and *Adele Bloch-Bauer* (pages 31 and 57). Luckily for Klimt, there were a number of upper-middle-class families in Vienna with a taste for artistic novelty, and he never lacked patrons. Sonja Knips was herself a devoted admirer who owned a number of his works, tastefully installed in the villa designed for her by the architect Joseph Hoffmann, with whom Klimt worked on the *Palais Stoclet*.

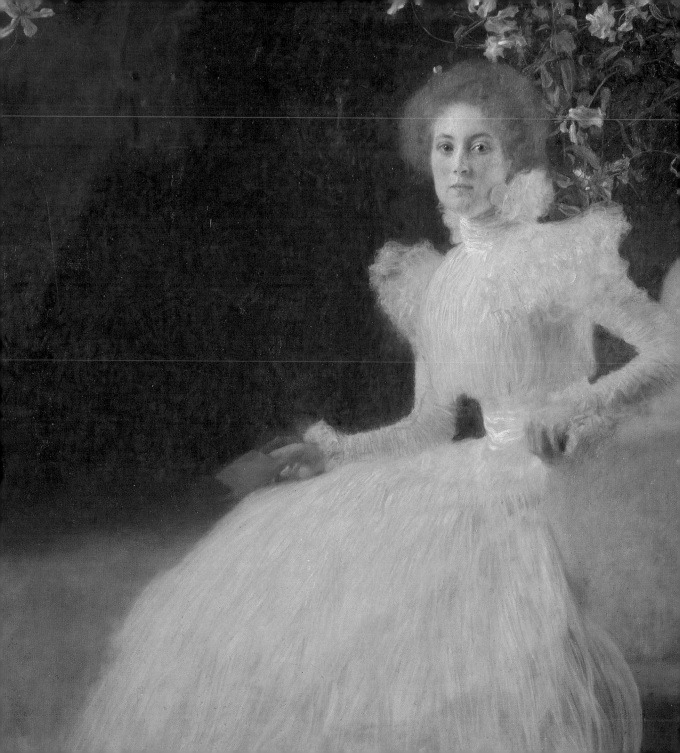

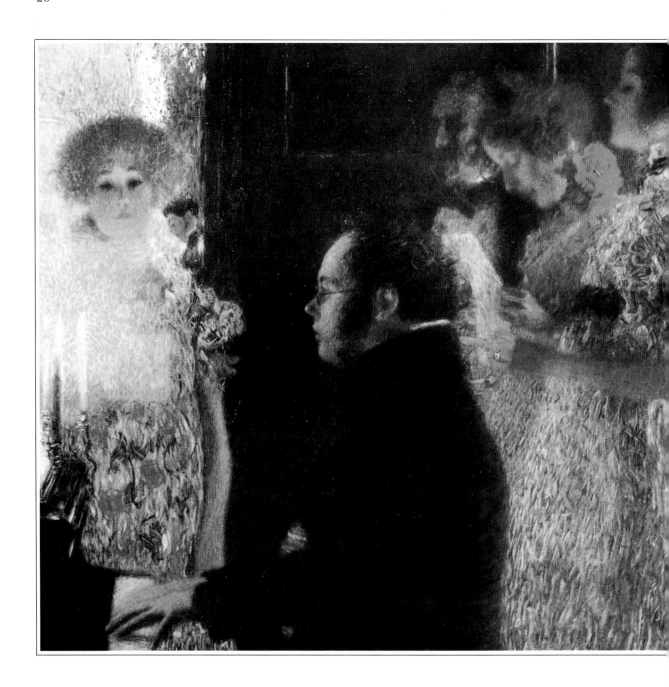

◁ **Schubert at the Piano** 1899

Oil on canvas

FRANZ SCHUBERT (1792-1828) was a Viennese composer whose brief, unhappy life and wealth of beautiful songs gave him a special appeal to the music-loving Austrians. Small, ugly and shy – except when in his cups – Schubert was at his best in the evenings spent among friends, known as Schubertiads, when his music would be played and sung. These could be quite boisterous occasions, but Klimt preferred to picture the composer in quieter mood, surrounded by lovely women in a misty, candle-lit atmosphere. In marked contrast to paintings such as *Theatre in Taormina* (page 15), executed for official institutions, this work has no great pretensions to historical accuracy in the matter of costume: the women in particular are very much Viennese of Klimt's own day. Like the painting for which *Music I* (page 18) is a study, *Schubert at the Piano* was commissioned for the music room of Nikolaus Dumba's villa and was destroyed by fire in 1945.

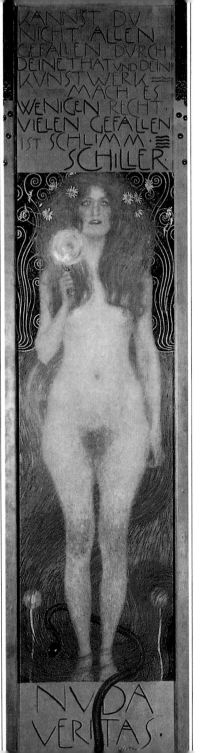

NVDA VERITAS.

◁ **Nuda Veritas** 1899

Oil on canvas

Nuda Veritas – NAKED TRUTH – is an enlarged version of the little Nike in *Pallas Athene* (page 23). Only the position of the arms is changed, the figure holding up the mirror of truth to the spectator. The snake can be interpreted as falsehood, slain by truth, and/or as a potent sexual symbol. The quotation is by the great German poet and dramatist, Friedrich Schiller: 'You cannot please everyone by your deeds and your art: do the right thing for the sake of the few. To please the many is bad.' This articulated the new direction taken by Klimt in the late 1890s and signalled by his adherence to the Secession; in fact, an earlier version of *Nuda Veritas* appeared in 1898 as a black-and-white illustration in the first edition of *Ver Sacrum,* the Secession's magazine. But as yet Klimt had not shed his reputation as an architectural decorator who pleased everyone: resulting from the scandal over the Vienna University paintings (pages 30 and 31).

▷ **Mermaids** c.1899

Oil on canvas

ALSO KNOWN AS *Silverfish* or *Water Nymphs*, this is one of several paintings by Klimt in which powerful erotic images of women are associated with water. The fishy presence seems to be identified with the male principle; it is often grotesque or lumpish (as in *Flowing Water*, page 21), and is shown more as a voyeur than an active sexual agent, though the silverfish in this painting could perhaps be interpreted differently. The mood in these paintings varies considerably. *Goldfish* (1902) is distinctly cheerful, with one of the girls in it thrusting her bottom out towards the spectator; apparently this was intended as Klimt's answer to his critics. Here, the mermaids – in legend a dangerous species – are vaguely sinister, heralding the appearance of the *femme* literally *fatale* (*Judith*, page 33) in Klimt's work.

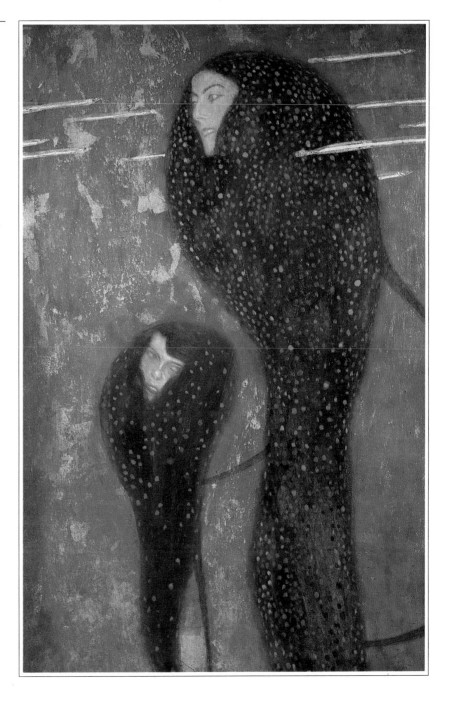

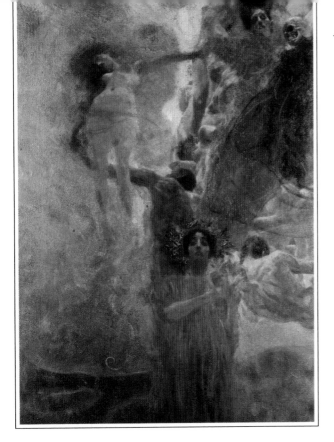

△ **Medicine (study)** 1897-8

Oil on canvas

THIS IS AN EARLY STUDY for one of the three large pictures which Klimt was commissioned to paint for the ceiling of Vienna University's Great Hall: *Philosophy, Medicine* and *Jurisprudence,* all of them destroyed in the Second World War. Though unfinished, *Philosophy* was seen at the seventh Secession Exhibition in 1900, provoking a storm of protest; and when *Medicine* was shown a year later, the controversy revived in its full force. Some alleged that the naked figures were obscene, but most took the line that Klimt's great columns of suffering humanity made a far greater impact, than the symbols of thought and healing that he was supposed to celebrate.

▷ **Hygieia (detail from Medicine)** 1900-7

Oil on canvas

THIS MAGNIFICENT, commanding figure is the only surviving record, in colour reproduction, of Klimt's three controversial paintings for the University of Vienna. She represents Hygieia, the Greek goddess of medicine, and appeared at the bottom of Klimt's completed version of *Medicine*. At some stage she replaced the less forceful figure, equivalently positioned, in the study painted in 1897-8 (left). Klimt may well have done this in response to criticisms of the picture's pessimism, emphasizing the brightness and strength of the healing power, which had previously seemed overborne by the tortured mass of humanity above. However, a black and white reproduction of *Medicine* demonstrates that, in its final form, it remained a stark testimony to pain and sorrow. During the Second World War, *Medicine, Philosophy* and *Jurisprudence* were taken for safety to Schloss Immendorf, which was destroyed by retreating SS troops.

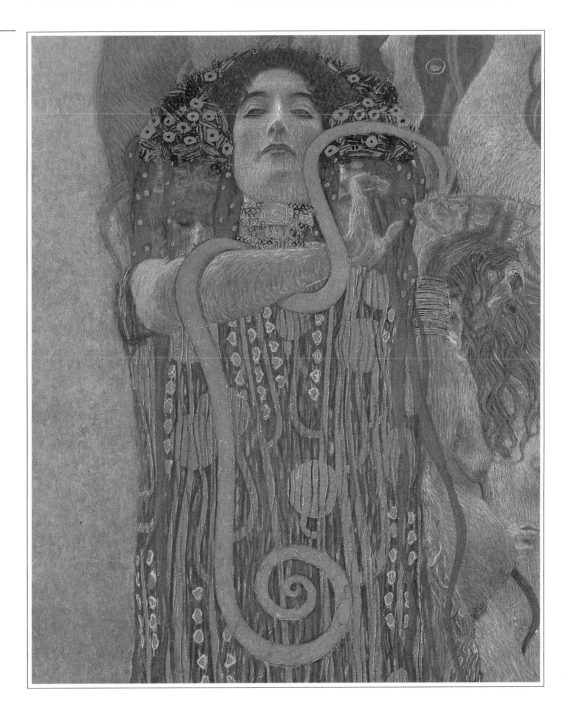

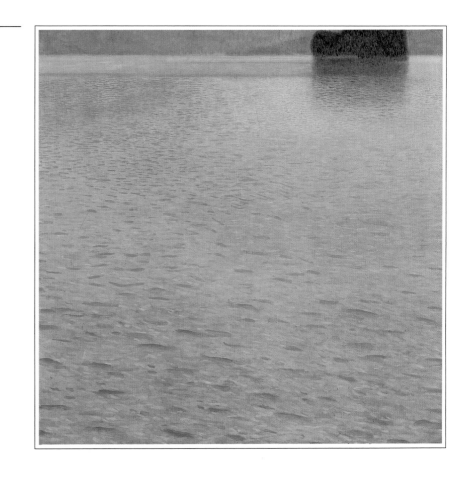

▷ **Island on the Attersee** c.1901

Oil on canvas

THE SCANDALOUS EROTICISM of Klimt's figure paintings ensured that their fame would outshine his landscapes, especially as views such as *Island on the Attersee* were holiday works, done for relaxation. In recent years, however, the landscapes have been re-evaluated and are now seen as major achievements in their own right, comprising about a quarter of his total output. He began surprisingly late, in his mid-30s, when he had become sufficiently well-established to take long summer holidays in the Salzkammergut, a beautiful region of lakes, forests and mountains. Some of Klimt's favourite spots were around Attersee, a lake in the north of the region. Early landscapes like this one have a fresh, open-air feeling, by contrast with the more decorative style that Klimt was soon to adopt. Here, the treatment of the water, with its coloured reflections, owes a good deal to the great French Impressionist Claude Monet; but the high horizon and sense of mystery are very much Klimt's own.

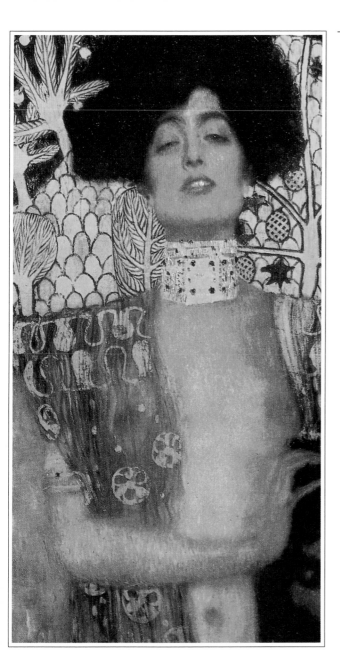

◁ **Judith and Holofernes** 1901

Oil on canvas

KLIMT'S TITLE FOR THIS painting was inspired by the apocryphal Biblical story in which a Jewish heroine saved her people from the hosts of Nebuchadnezzar, king of Assyria. Judith, a beautiful young widow, entered the Assyrian camp to meet the commander-in-chief, Holofernes. He soon became enamoured with her, but she plied him with drink and then, as he slept, cut off his head. Judith's obvious modernity and air of sensual gratification make it unlikely that Klimt intended the spectator to take the Biblical reference too seriously, although the severed head adds a disquieting note. Like much art and literature of the period, it suggests that woman's sexuality may be a destructive force. The model for Judith was Adele Bloch-Bauer, portrayed in two other pictures (pages 57 and 66).

▷ **The Longing for Happiness,
from the Beethoven Frieze** 1902

Mixed media on plaster panels

KLIMT'S GREAT *Beethoven Frieze* was created as a compliment to the work of another artist. The Leipzig sculptor Max Klinger arranged to exhibit his statue of Beethoven at the Secession, and Klimt and his friends refurbished the entire Secession building as a kind of Beethoven temple and tribute to Klinger. Klimt's contribution was a frieze running along three walls of a room and consisting of four main scenes (this one and pages 36 to 41) linked by repeated floating female figures symbolizing the longings that drive humanity onwards. The scenes were suggested by Beethoven's Ninth (Choral) Symphony, although it would be difficult to establish the connections without the descriptions in the exhibition catalogue (presumably approved by Klimt). In *The Longing for Happiness,* 'suffering, feeble humankind' appeals to the 'strong, well-armed' knight in golden armour for help, invoking compassion and ambition as moving forces in the struggle for happiness. The knight is said to be a portrait of the composer Gustav Mahler, who took part in the Beethoven celebrations.

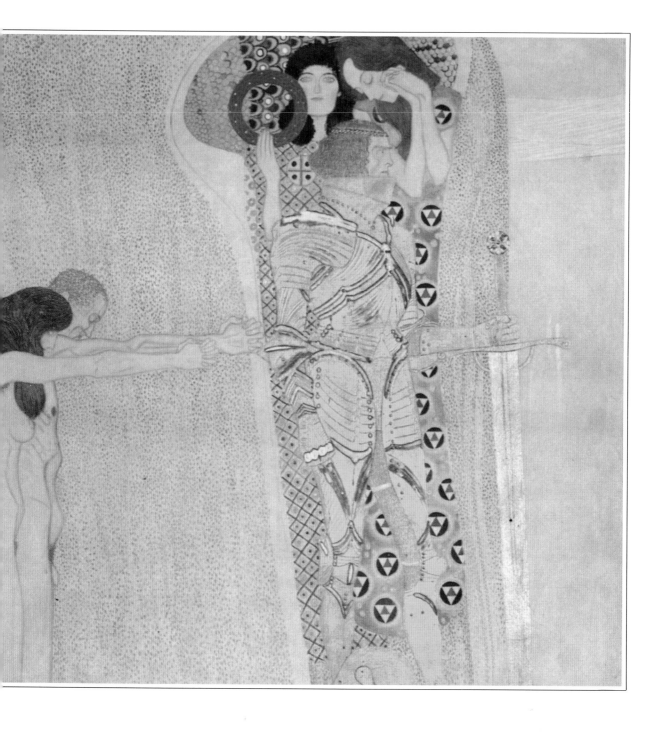

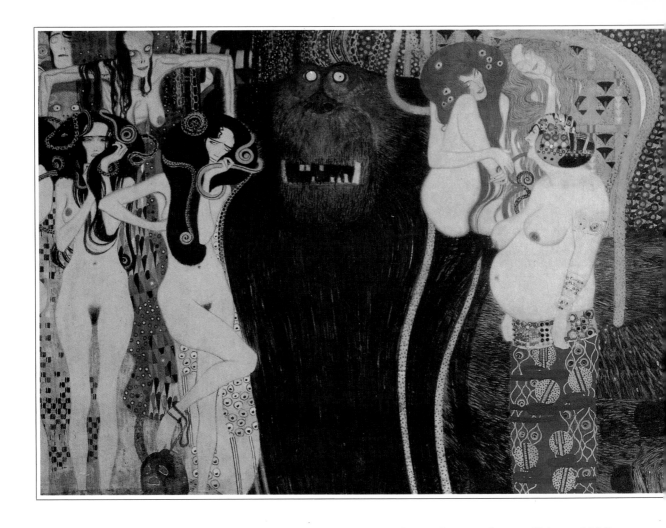

△ **The Hostile Powers, from the Beethoven Frieze** 1902

Mixed media on plaster panels

THE DARKEST AND DENSEST of the *Beethoven Frieze* panels, *The Hostile Powers* represents an infernal region full of snares for the human soul. According to the exhibition catalogue, the huge ape represents 'the giant Typhoeus, against whom the gods themselves fought in vain', with his three gorgon daughters (Sickness, Madness,

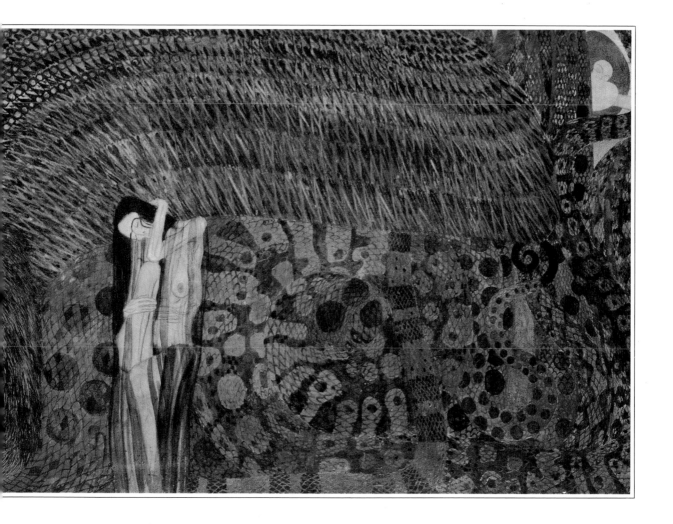

Death) and their victims beside him. The central figures represent Debauchery, Unchastity and Excess. Excess is very much a tribute to the British graphic artist Aubrey Beardsley, with a distinct resemblance to Beardsley's Ali Baba. But the other two figures come from Klimt's private erotic pantheon and in another context might not be perceived as warranting rejection! To the right, clutching herself and trapped in a kind of dark winding sheet, is the gaunt figure of Corroding Grief.

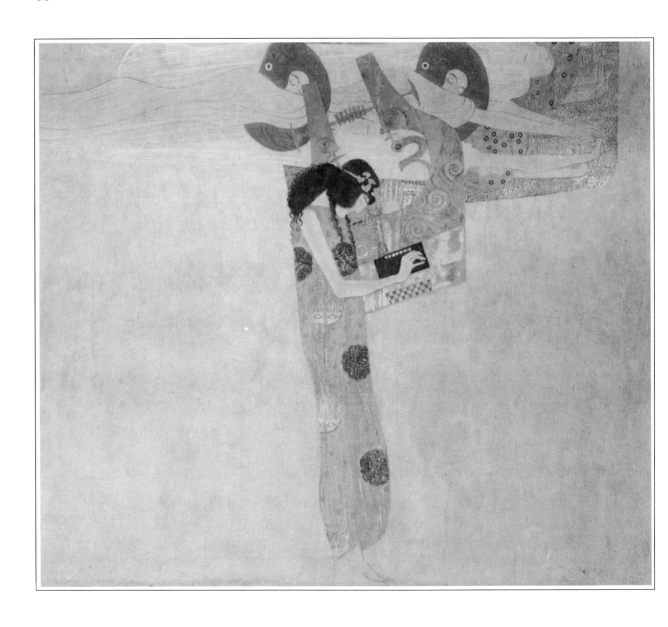

◁ **The Longing for Happiness Fulfilled in Poetry,
from the Beethoven Frieze** 1902

Mixed media on plaster panels

IN THIS, the third scene from the *Beethoven Frieze,* the longings of humanity, symbolized by the floating, apparently somnolent female figures, have flown above and beyond the Hostile Powers (pages 36-37); they have arrived in the realms of art, symbolized by the woman playing the harp. And, as the exhibition catalogue proclaims, 'The arts lead us into the kingdom of the ideal, where alone we can find pure joy, pure happiness, pure love.' Here Klimt was only expressing the widespread aesthetic 'religion' of the 1890s and 1900s , based on the conviction that art is not just a pleasure, or even a profound experience, but a way of life and a path to salvation. This was, in fact, the message of Max Klinger's statue of Beethoven (who was shown as a semi-divine being) and the point of the temple to Beethoven raised by the Secession artists (see page 34).

A Kiss for the Whole World, from the Beethoven Frieze
1902

Mixed media on plaster panels

THE CULMINATING SCENE of the *Beethoven Frieze*. Klimt has tried to create a visual equivalent to the passionate choral outburst (Schiller's *Ode to Joy)* at the end of Beethoven's Ninth Symphony. In this picture there is a choir, but the strength and joy are conveyed more forcefully by the wealth of decoration and the powerful embrace of the naked couple. Finally, though he may picture *Debauchery, Unchastity* and *Excess* as vices (pages 36-37), Klimt can only describe life's fulfilment in erotic terms. For all its ambition, the *Beethoven Frieze* was intended as throwaway art: the frieze was relatively fragile plaster, painted and embedded with gold and silver leaf, mother of pearl, mirror glass and other items. Klimt's was the only decorative work to be rescued, by the intervention of a wealthy collector.

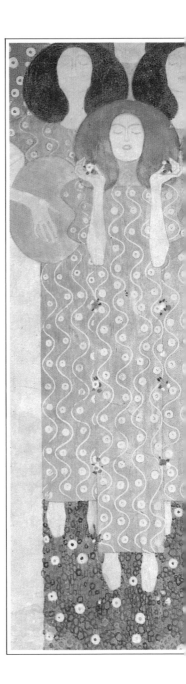

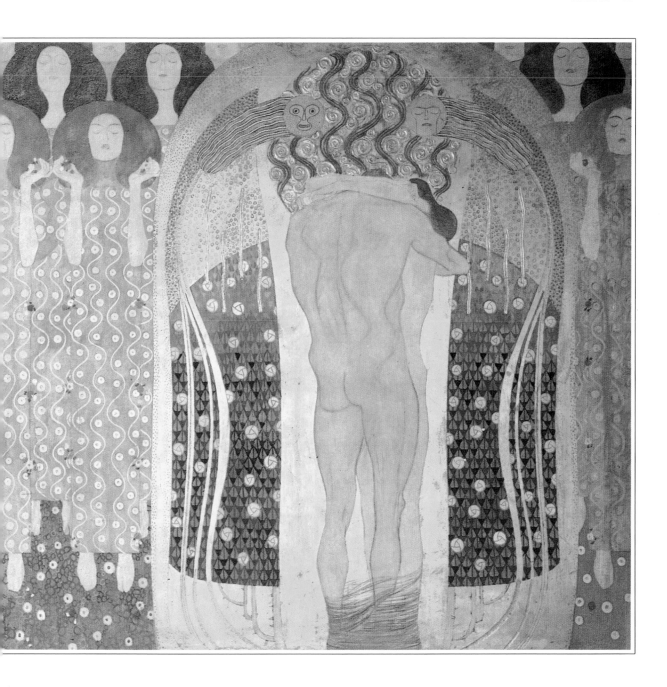

▷ **Portrait of
Emilie Flöge** 1902

Oil on canvas

THIS STUNNING PORTRAIT
marks the beginning of a new
phase in Klimt's art,
characterized by his use of
large areas of detailed
decorative patterning which
almost engulf his human
figures, leaving only their faces
and hands visible and treated
in naturalistic fashion. Klimt
did not yet dare to go this far
in commissioned portraits (for
example, pages 25 and 45),
but the *Portrait of Emilie Flöge*
was a labour of love for the
woman who was his
companion for the last 25
years of his life. They never
married and, although Klimt
had a good many affairs, it
seems likely that he and Emilie
were never physically intimate.
Emilie Flöge was Klimt's sister-
in-law (his brother Ernst, who
died in 1892, had married
Emilie's sister), so Klimt was
able to play the family friend,
escorting Emilie to the theatre
and spending his holidays with
the Flöges without disturbing
the proprieties.

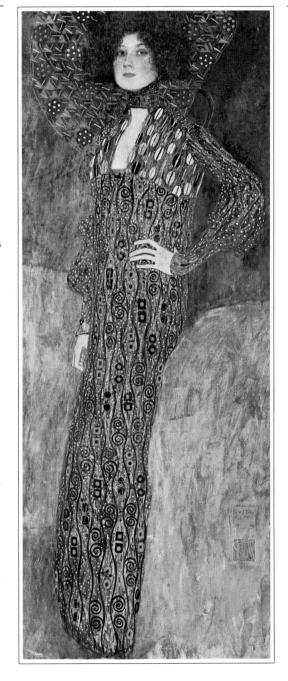

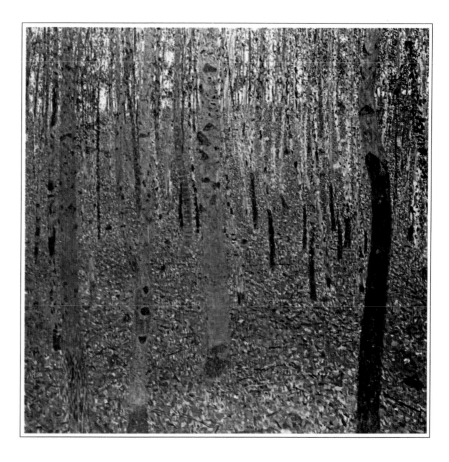

▷ **Forest** c.1902

Oil on canvas

KLIMT WAS A WORKAHOLIC whose idea of relaxation was to switch to a different kind of work. In Vienna he painted from ten in the morning to eight at night, occasionally taking time off when he drew one of the models whom he kept on call for the purpose; and on holiday he painted landscapes. In a letter written to one of his mistresses in 1903, Klimt describes a typical day at Kammer on the Attersee as beginning when he got up about six and went into the forest to paint for a couple of hours before breakfast; later, between bathing and outings, he would put in a couple of sessions on other subjects. This picture is one of his forest scenes, painted from an unusual angle that cuts off the tops of the trees and concentrates the attention on the shadowed silvery trunks and the forest floor scattered with leaves and branches. Its combination of natural beauty with a composition of near-abstract parallelism is striking indeed.

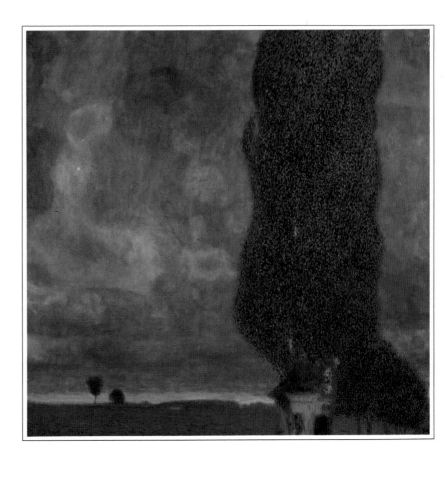

▷ **The Tall Poplar II** 1903

Oil on canvas

IN A LETTER OF 1903
describing his holiday activities
(see the caption on page 32)
Klimt records going out to
paint 'a large poplar at dusk as
a storm is coming on'. *The Tall
Poplar II* was almost certainly
the work in question. Unlike
almost all of his landscapes, it
has a very low horizon, with
the sky and the enormous tree
as its dominant features. Its
emotional turbulence is also
unusual, created by the
combination of a murky sky
and the shape of the poplar,
which not only appears to be
moving but might easily be a
whirlwind of the 'twister' type,
sucking up everything in its
path. The eye-dazzling
vibrancy of the poplar leaves is
a *tour de force* of pointillist-style
painting.

▷ Portrait of Hermine Gallia 1903-4

Oil on canvas

THIS PORTRAIT HAS very much the air of a grand commissioned work, destined to add dignity to the family that owned it. Unlike the somewhat earlier *Portrait of Emilie Flöge* (page 42), the painting is highly naturalistic, with only a hint of Klimt's obsessive pattern-making in the woman's train and on the carpet. Having given up his work as a government-sponsored decorator, Klimt was dependent on private patrons from the Viennese upper middle class; generally speaking, they were remarkably sympathetic to his experiments, but the evidence of the portraits from this period is that he advanced with some caution. This is a very successful example of its kind, evoking a very definite physical presence. Mme Gallia's dress is in a style that suggests it may have come from the salon run by Emilie Flöge and her sister.

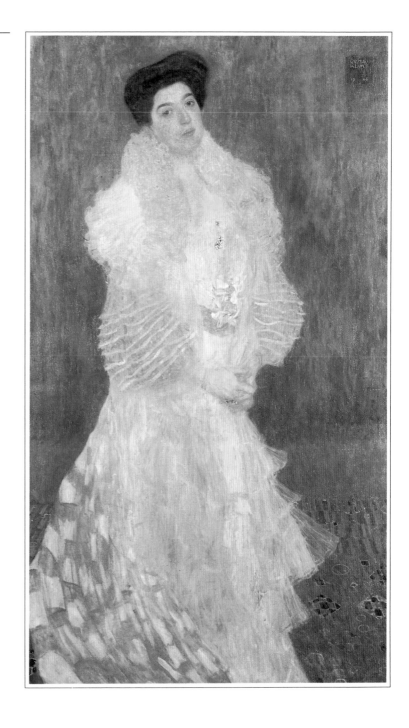

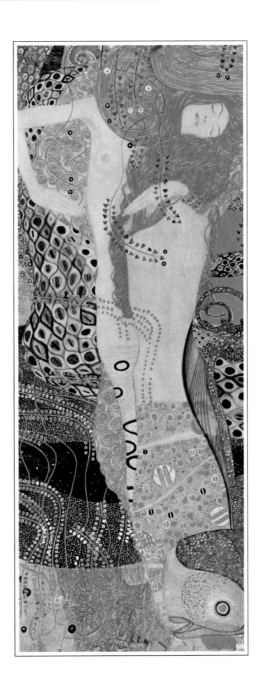

Detail

◁ **Water Snakes I** 1904-7

Mixed media on parchment

A GREAT DEAL can be learned about the 19th century by setting the painting of *Hermine Gallia* (page 45) beside *Water Snakes,* which was begun at about the time the portrait was completed. Like a textbook illustration of 'Victorian values', the result is a contrast between formal respectability and erotic ardour, or in Freudian terms between the world of consciousness, directed by the Super-Ego and Ego, and the dangerous forces of the Id, identified with the unconscious. Even the notional setting of snakes in a watery medium is a regression to the primal realm, although Klimt includes a characteristically light note in the form of a small, charming whale (perhaps a male voyeur?). This gorgeously decorative fantasy of lesbian love was bought by the industrialist Karl Wittgenstein, whose daughter was painted by Klimt (page 50) without any suggestion that water snakes or whales played any part in her life.

▷ **Three Ages of Woman** 1905

Oil on canvas

AS AN ALLEGORY, this belongs to the same class as *Medicine* (page 30) and the other controversial pictures done by Klimt for Vienna University. In fact the meaning is more obvious in this private work (and, in the conventional sense, more acceptable) than it was in the officially commissioned painting. Viewed simply as an allegory, the *Three Ages* is rather banal, presenting an all-too-familiar contrast between infancy, maturity and old age. On this level its most interesting feature is the treatment of old age, in which all the emphasis is on its bodily ugliness. Moreover, the old woman is shown as weeping or stricken rather than reconciled or serene – perhaps a reflection of Klimt's own passion for evanescent physical beauty. But the most striking aspect of the painting is the splendid richness and variety of the abstract decoration, which was to play an ever greater role in Klimt's work (for example, in pages 65, 66 and 71) down to about 1909.

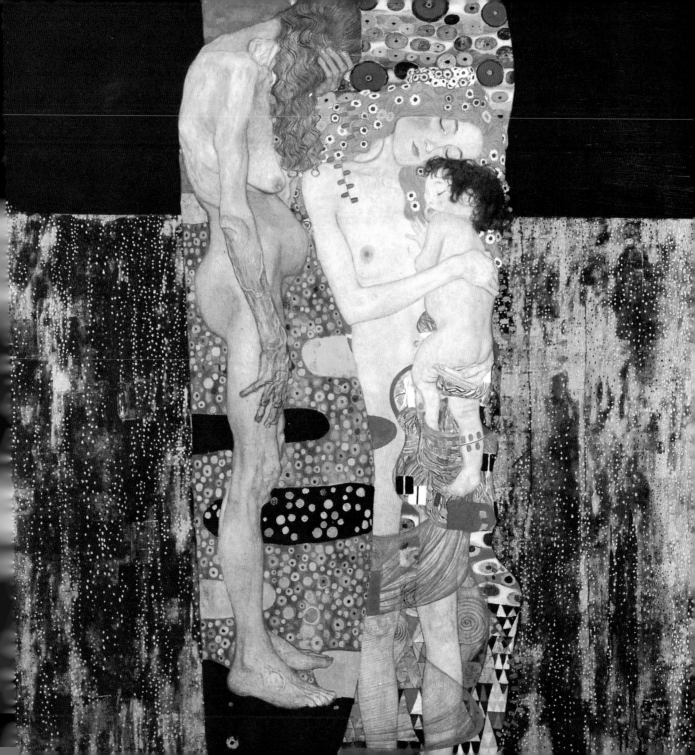

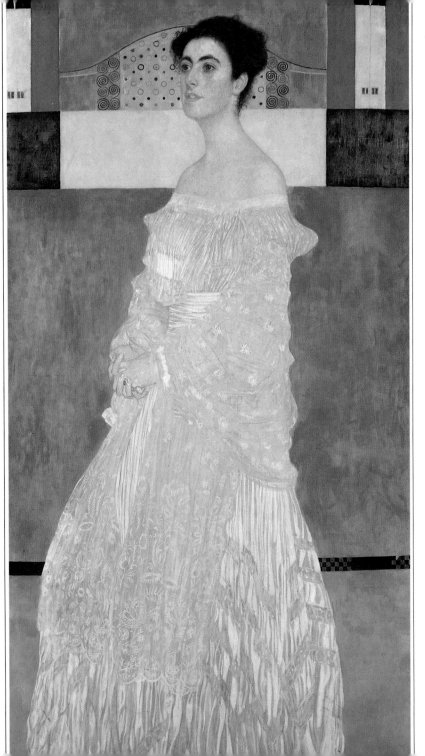

◁ **Portrait of Margaret Stonborough-Wittgenstein** 1905

Oil on canvas

MARGARET STONBOROUGH-WITTGENSTEIN was the daughter of the wealthy industrialist Karl Wittgenstein, one of Klimt's most important patrons; among other works by Klimt, he owned *Water Snakes* (page 46). The portrait here was painted for Wittgenstein to give to his daughter on her marriage to Thomas Stonborough, an American doctor. Klimt makes her face and hands seem extraordinarily alive. By contrast, her dress and shawl, though painted in a masterly 'white-on-white' fashion reminiscent of the American artist James McNeil Whistler, are discreetly restrained. Margaret's brother was Ludwig Wittgenstein, one of the 20th century's most celebrated philosophers. She herself was a woman of taste and ability; she disliked Klimt's portrait of her, perhaps resenting its conventional suggestion of girlish innocence and timidity.

▷ **Country Garden with Sunflowers** 1905-6

Oil on canvas

KLIMT WAS FOND of flowers, letting the garden in front of his studio run wild. However, *Country Garden with Sunflowers* is a vacation picture; like his landscapes, it was painted as a form of relaxation and on the standard square canvas he used for this kind of work. The flowers grew in the garden of an inn at Litzberg on the Attersee, where Klimt regularly spent the summer. By concentrating on one crowded patch of blossoms – seen close up, without a horizon or anything to locate them – Klimt created a picture of wonderful intensity, bursting with life. Like so much of Klimt's art during this period, *Country Garden* is mosaic-like in detail and colouring; but its naturalness is in the greatest possible contrast to the abstract decoration so characteristic of his contemporary 'town' works.

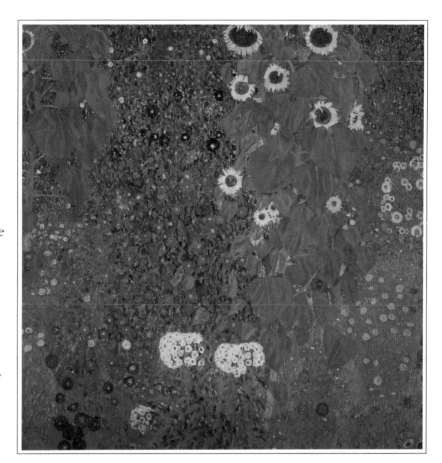

▷ **Portrait of Fritza Riedler** 1906

Oil on canvas

BY THE TIME this was painted, Klimt's passion for large-scale decorative patterns had started to take over and dominate the human element in his portraits. The striking effects he achieved were without any significant precedent in the history of portraiture. What makes such a development even more surprising is that Klimt's patrons – wealthy, upper-middle-class Viennese – cheerfully accepted images of themselves that were so much at variance with convention. Whereas most of them came from industry and commerce, Fritza Riedler was the German wife of a top Viennese civil servant; it is a pity that little more is known about her, since her portrait marks a definite stage in Klimt's development. The spectator does not immediately identify as a chair the astonishing mass of 'peacock-eyes' that envelop her, while the decorative panel behind her head might be a stained-glass window or a headdress in the Spanish style! However, the future would show Klimt following his decorative impulse much further, almost to the point of complete abstraction.

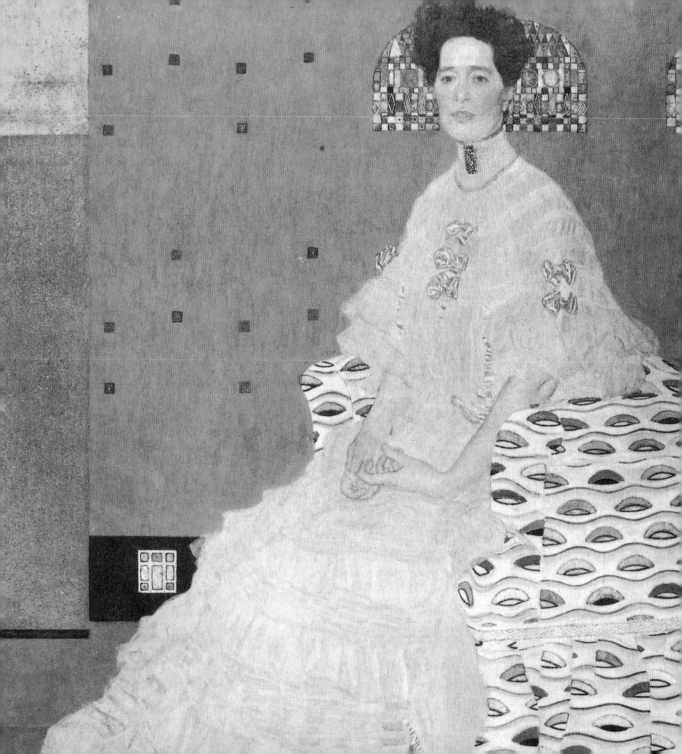

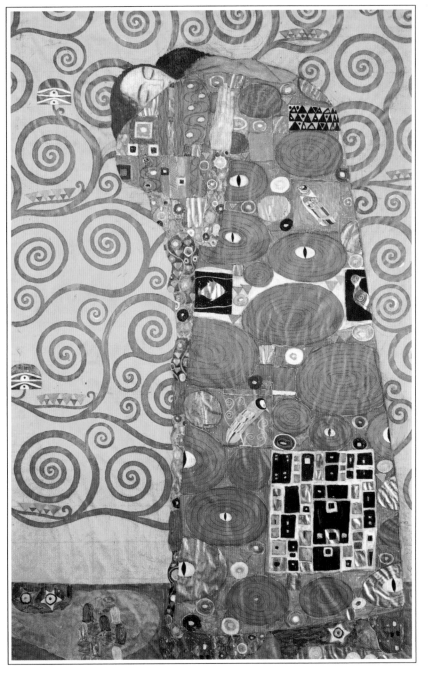

◁ **Fulfilment** 1905-9
Cartoon for Stoclet Frieze

Mixed media on paper

THIS IS A CARTOON painted for the most remarkable of all Klimt's murals. Klimt's architect colleague Josef Hoffmann was given the opportunity to build and furnish the 40-room Palais Stoclet in Brussels. Many Viennese artists were involved but the *pièce de resistance* was the dining-room, for which Klimt designed three mosaics made of semi-precious stones, enamels, mother of pearl, coral and other costly materials. The two main mosaics were long friezes; *Expectation*, featured a single female figure, but in *Fulfilment*, a couple embraced. In the cartoon for *Fulfilment*, Klimt has used a variety of media to mimic the textures of the final work. Klimt remarked that the *Stoclet Frieze* was 'probably the ultimate stage in my development of ornament', which almost completely engulfs the human figures. The third, small mosaic is the ultimate – an entirely abstract panel.

▷ **Field of Poppies** 1907

Oil on canvas

ONE OF KLIMT'S most hallucinatory pictures – visually vivid and busy, although confusing to the eye and mind insistent on sorting out objects and establishing distances between them. Here, Klimt's decorative impulse is held in almost painful tension with the necessity to give a recognizable account of the real world. As in so many of his landscapes, Klimt has set the horizon very high, excluding any area of 'weak' sensation and forcing the eye to go on moving over the quivering mass of blossoms and fruits. Some respect is paid to perspective – the poppy heads and the trees do get smaller with distance – but there is no illusion of colour fading towards the horizon (aerial perspective) to spoil the effect of an overall decorative design. By such means Klimt created a picture of extraordinary excitement and vibrancy.

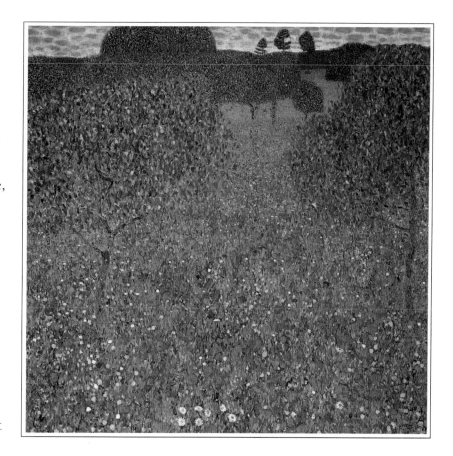

Detail

▷ **Portrait of Adele Bloch-Bauer I** 1907

Oil on canvas

This handsome creature was the wife of the banker-industrialist Ferdinand Bloch-Bauer and, almost certainly, Klimt's mistress. She was the only woman whose portrait he painted twice (see page 66), and she also posed for the man-slaying heroine of *Judith and Holofernes* (page 33). Her willingness to serve as Klimt's model, at a time when women who did so were regarded as little more than street girls, certainly suggests an exceptional intimacy. Here, Klimt has treated her royally – almost literally. Her face and hands are as fully alive as any portrait subject could desire, while the unbelievably opulent gold and silver setting raises her to the status of a divinity in a mosaic. The comparison takes its point from Klimt's admiration for the 6th-century Byzantine mosaics in Ravenna, the most famous of which shows the Empress Theodora and her retinue; the gold-encased Viennese society woman, with her air of sexual power, can be seen as a modern counterpart to the Byzantine autocrat.

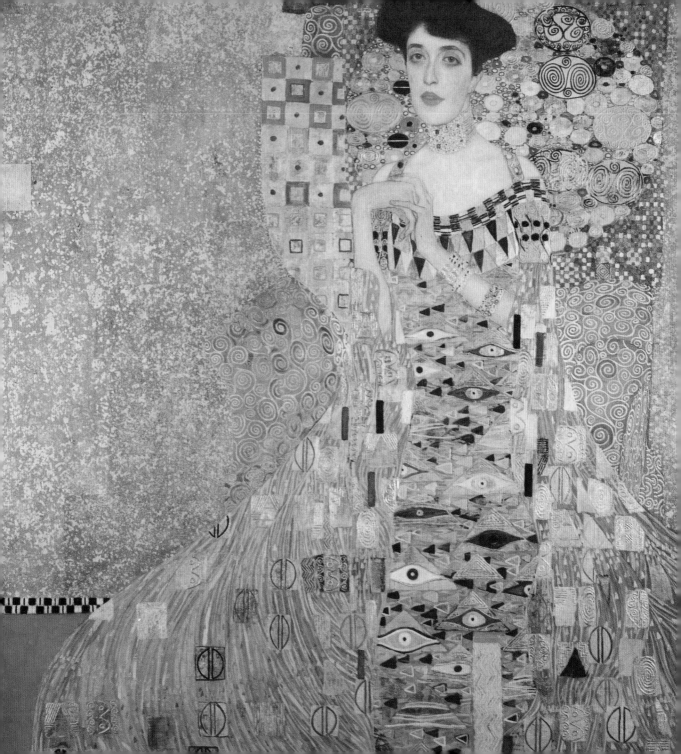

△ **Danaë** 1907-8

Oil on canvas

IN PASSING OFF his more flagrantly erotic inventions as scenes from mythology, Klimt was acting in a grand artistic tradition stretching back at least as far as the 16th century, when Titian painted a series of delicious fleshy *poesie* for Philip II of Spain. Danaë was the daughter of a king of Argos who shut her up in a tower where no man could reach her, until Zeus, the lustful and enterprising king of the gods, transformed himself into a shower of gold in order to enjoy her. Given Klimt's love of gold as a decorative medium, the story probably did have a certain appeal for him. However, the woman's flushed face and drawn-up knees leave us in no doubt that her heavenly moment needs no mythological explanation to make it understandable. In terms of Klimt's art, the curving lines and eliptical shape of Danae look forward to the freer, less patterned style of his later years.

▷ **The Kiss** 1907-8

Oil on canvas

The Kiss IS THE most celebrated of all Klimt's paintings, and is generally regarded as the apogee of his 'golden' period, in which glittering geometric ornamentation threatened to engulf his painted human figures. Here the balance is successfully held because of the compositional strength and emotional force of the figures, expressed through the compact kneeling pose, the man's powerful embrace and the woman's ecstasy. Gold and silver leaf are lavishly used around the couple, but they kneel on a delightful bank of flowers. The man's cloak is patterned with black and white rectangles whose angularity contrasts with the softer, more colourful, flower-like decoration of the woman's garment. Most of Klimt's works are open to interpretation, but his use of embracing couples on the *Beethoven* and *Stoclet friezes* (pages 35 and 54) makes it hardly possible to doubt that *The Kiss* represents the ultimate human fulfilment.

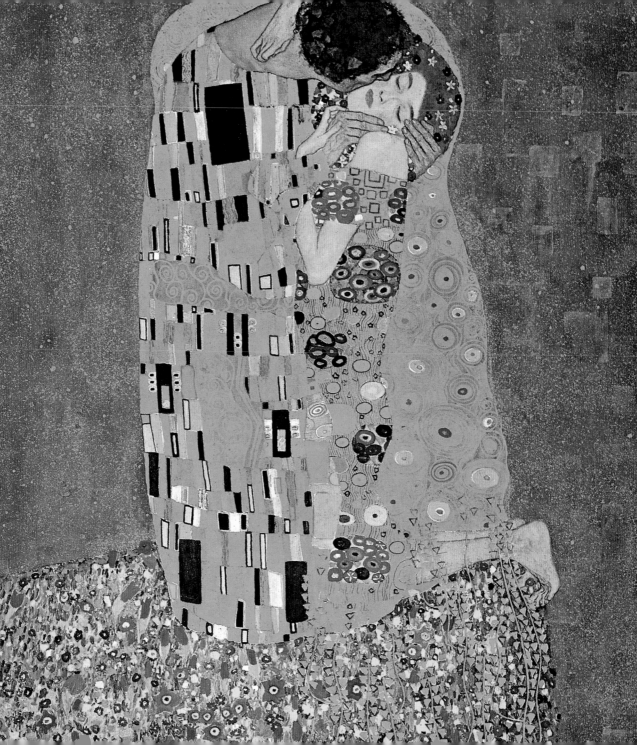

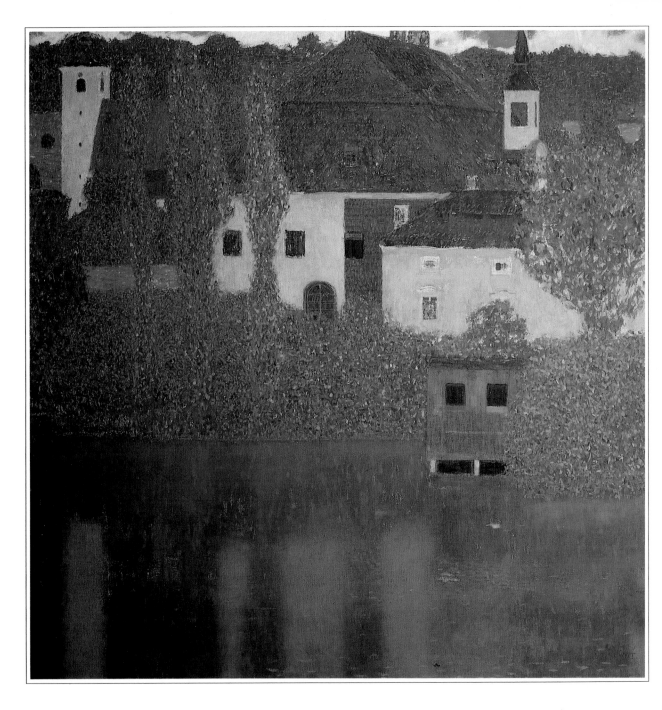

◁ **Schloss Kammer on the Attersee I** 1908

Oil on canvas

IN 1897 KLIMT spent his first holiday at Kammer on the Attersee with his companion Emilie Flöge and her family. He returned to the lake for two or three months every summer as a member of the same party. Photographs of the period show Klimt and Emilie out in a boat, with the artist dressed in the full-length 'monk's robe' he wore during working hours in his Vienna studio. Many of Klimt's landscapes were painted from such a boat, with the aid of a little ivory square which he could look through to 'frame' the scene and a pair of binoculars to help him pick out interesting details. Between 1908 and 1910 he painted four views of Schloss Kammer seen from the lake; this one, the first, is particularly successful in exploiting the contrast between the solid geometry of the house and its melting reflection in the water.

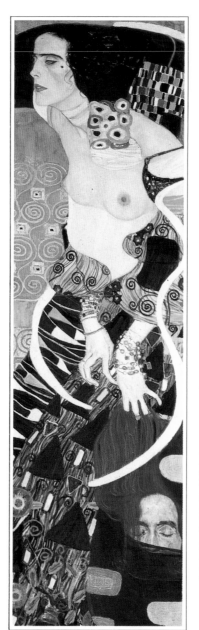

◁ **Judith II** 1909

Oil on canvas

As IN *Judith and Holofernes* (page 33), the subject of this painting is the Biblical heroine who enticed and then slew the Assyrian general Holofernes. In reality, both Judiths display the kind of 'fatal woman' who obsessed so many artists (and patrons): in the guise of Homeric sirens, vampires, sphinxes or barbaric goddesses, women were portrayed as destroyers of men, employing their sexual power to castrate and kill. Klimt's choice of Judith for the role was somewhat odd – so much so that after his death his Judith was often retitled *Salome,* after the princess who danced before Herod to gain the head of St John the Baptist. Klimt's second vamp is much fiercer than her predecessor. Her hawklike features and bared breasts are startlingly aggressive, reinforced by areas of daggerlike ornament; her fingers are long and prehensile, holding the head of Holofernes by the hair.

▷ **Woman with a Hat and Feather Boa** 1909

Oil on canvas

AROUND 1907-10 KLIMT painted a group of portraits of women wearing extravagant hats and enveloped in high-collared coats or voluminous feather boas. Titles such as *The Black Feathered Hat* and *Hat with Roses* suggest that these pictures were intended to celebrate the allure with which fashion endowed women; the women themselves remain anonymous, which almost certainly means that they were working-class models dressed in finery provided for the occasion by Klimt. All the same, this amiable creature, half hidden behind her boa, looks the epitome of Viennese chic.

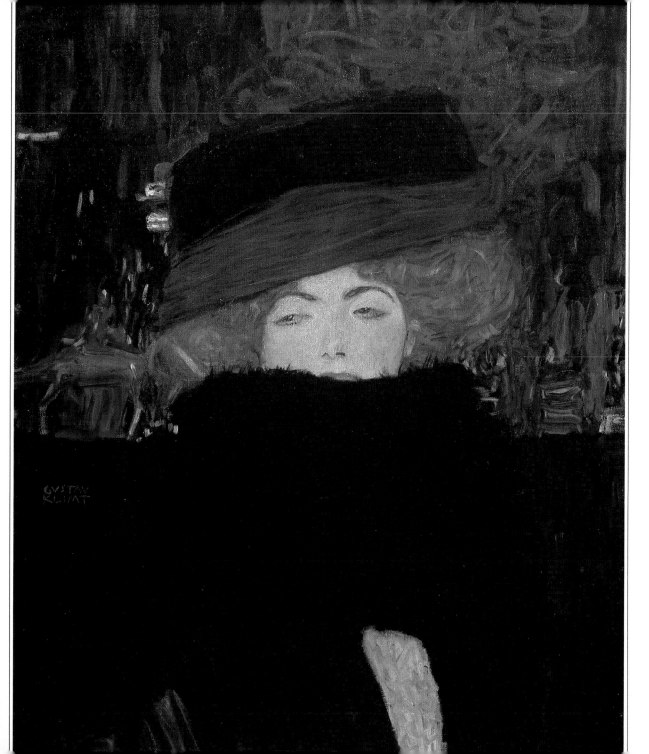

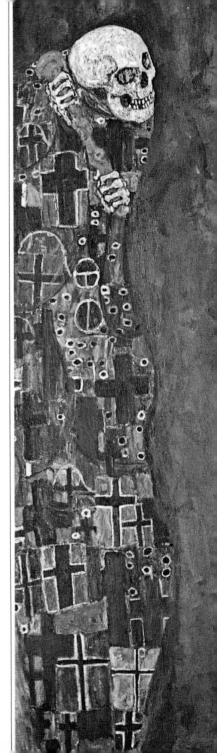

▷ **Death and Life** 1911-15

Oil on canvas

Death and Life is the last of Klimt's great allegories, at least in the sense of subjects whose abstract or general titles give a clear indication of their inner meaning; later titles of works by Klimt, such as *The Virgin* and *The Bride,* are poetically suggestive rather than programmatic. Here, huddled humanity and grinning, skeletal death in his sinister, cross-strewn robe are confronted in a fashion that is time-honoured, however unusual the style. The painting won First Prize at the 1911 International Exhibition in Rome, but remained unsold and was subsequently altered. It originally had a gold background of the kind favoured by Klimt for so many years, but he later painted it over in deep blue and also altered the main group of figures, presumably to bring the work more into line with his current style.

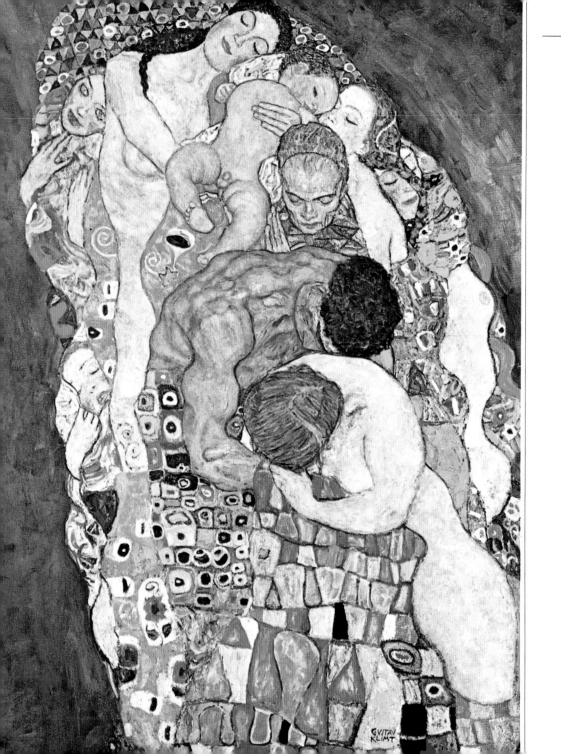

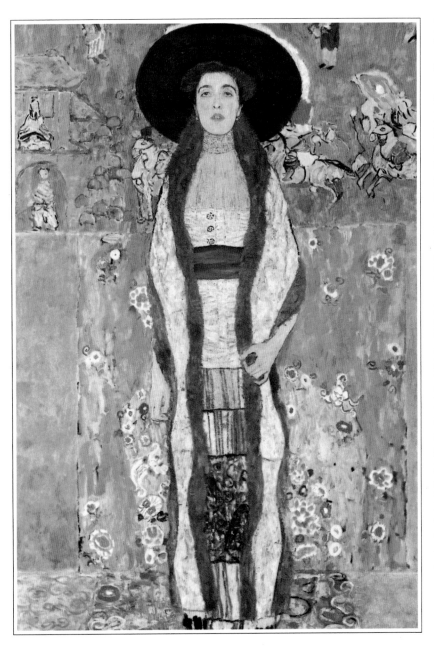

◁ **Portrait of Adéle
Bloch-Bauer II** 1912

Oil on canvas

SOMEWHERE AROUND 1910,
Klimt began to move away
from his established style,
abandoning lavish use of gold,
creating a richer paint surface,
and using less angular forms
and softer, brighter colours.
An early enthusiast for the new
style was Adéle Bloch-Bauer,
who persuaded the artist to
paint this second portrait of
her, very different from page
57. She is shown standing, in a
frontal pose that Klimt
favoured from this time.
Though the style remains
highly decorative, the
background is based on
oriental textiles owned by
Klimt, with floral and figure
designs. Adéle is no longer
encased in gold, or presented
as a dominant, erotic being.
She is visibly a Viennese
society woman in a huge hat,
beautifully dressed, and
looking over our heads
abstractedly. It would be
interesting to know which
image of herself she preferred.

▷ **Avenue of Trees, Schloss Kammer** 1912

Oil on canvas

THIS IS ONE OF THE MORE experimental landscapes painted by Klimt during his lakeside summer holidays in the Salzkammergut, perhaps reflecting his foreign travels and new developments in his figure painting. The house at the end of the avenue is one he had painted several times before (see page 32), this time viewed from its land side. No longer needing to emphasize the geometry of the building by contrast with the waters of the lake, Klimt makes its dignified 18th-century character more apparent. This also serves to emphasize the real subject of the painting – the rows of great trees, their gnarled boughs forming an aerial forest as they reach towards the sky. The influence of van Gogh is apparent in this emotionally expressive treatment, with its highly visible handling of paint and sense of menace in nature. For Klimt it proved an interesting but isolated stylistic venture.

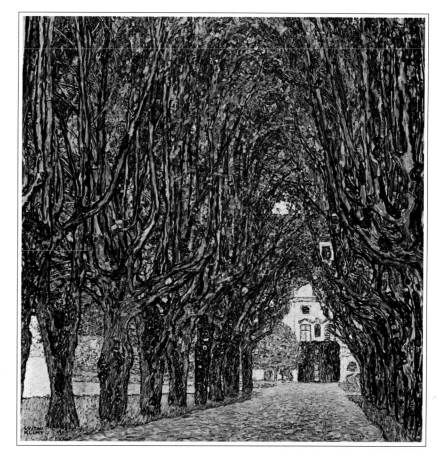

▷ **Malcesine on Lake Garda** 1913

Oil on canvas

KLIMT SPENT MOST of his summers, and painted most of his landscapes, around Attersee in the Salzkammergut. But in 1913 he made an exception and took an Italian holiday, staying in the environs of Lake Garda during July and August. The two landscapes known from this period are views of little lakeside resorts, Cassone and Malcesine, both painted from (or as if from) a boat; this was a practice Klimt had already adopted during his Austrian holidays, for *Schloss Kammer on the Attersee* (page 32) and other works. As in so many of his landscapes, Klimt virtually eliminates the sky; even the lake occupies only a small area of the canvas, so that the painting becomes a 'close-up' of the town, with the intricate geometry of the roofs zig-zagging down to the waterside. The picture was destroyed in 1945.

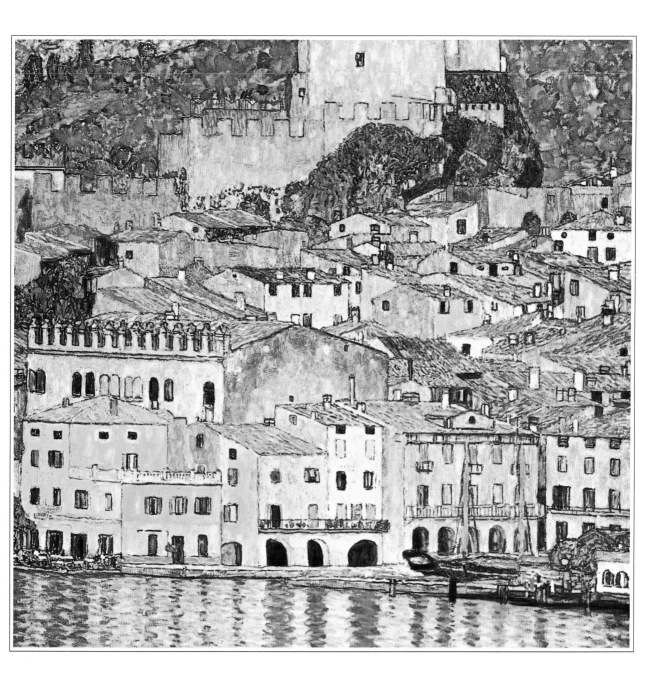

Details

▷ **Virgin** 1913

Oil on canvas

IN THIS PAINTING, the crowded, irregularly-shaped human mass of *Death and Life* has expanded and become a feminine dream world into which no men are allowed – or perhaps it would be more accurate to say that men do not participate, but that the male voyeur is an unseen presence, outside the picture frame. There is something irresistibly reminiscent of a slowly circling galaxy about this group of young women, all tucked up together and yet separated by their complete self-absorption. The most plausible interpretation of the group is that the central figure, fast asleep and modestly covered up, is the virgin; the other women, in a variety of erotic conditions from receptiveness to satiety, represent the virgin's dream-selves or alternative possibilities. However, Klimt's title may have been intended as no more than a starting point for the sexual-aesthetic reverie that a work of this kind was designed to induce.

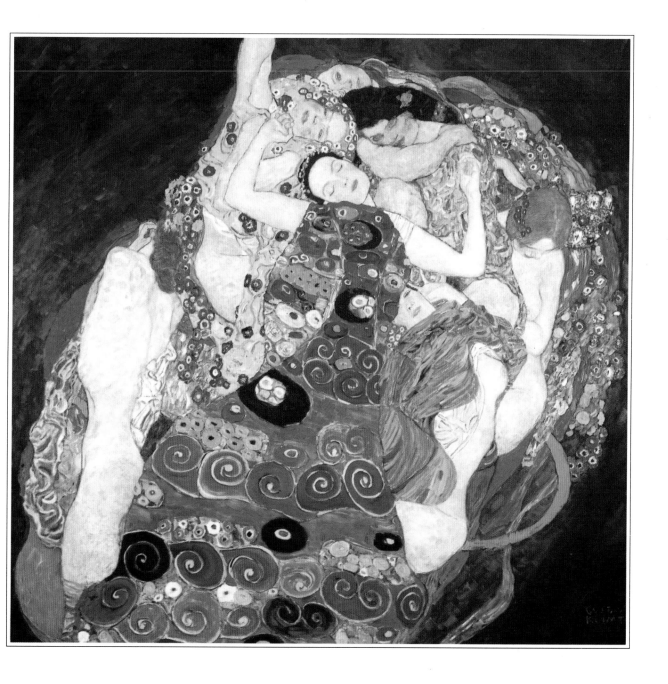

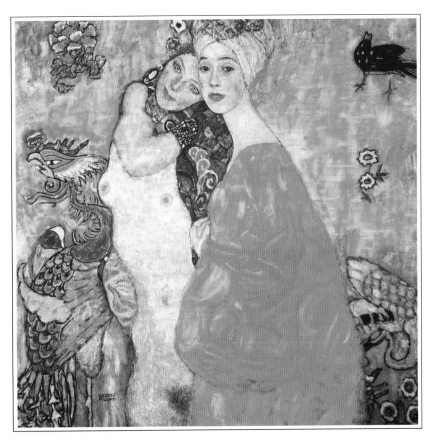

◁ **Women Friends 1916-7**

Oil on canvas

IN MOST OF KLIMT'S paintings, the naked body is an essentially anonymous vehicle for erotic feeling or the symbol of a general condition such as old age; nakedness strips both women and men of individual personalities. This is not a criticism of Klimt's work, since it can be argued that, like D.H. Lawrence, he sees the personality as no more than a superficial social construction, deceitfully masking the universal Eros. All the same, it comes as a pleasant shock to look at a picture like *Women Friends,* portraying with a tender charm a couple whom one can imagine as having homes, friends and interests. The sense of gentle intimacy is very strong, enhanced by the warm colours, soft fabrics and fantastic bird and flower motifs of the textile background; the long neck and turbaned head of the dressed figure gives the picture a suggestion of classical dignity. The picture was destroyed in 1945.

▷ **The Dancer** c.1916-18

Oil on canvas

LIKE A NUMBER of late paintings by Klimt, the enchanting *Dancer* has a bright, soft, kindly quality that is new in his art. Here, decoration based on natural forms has almost entirely superseded the golden geometric ornament of earlier years. More than any other portrait by Klimt, the picture is a celebration of flowers: the dancer holds a bouquet and blossoms are massed in the hanging behind her, on the table and, in more stylized form, on her wrap. But although surrounded by colour she is not engulfed by it, and the brightnesss and softness of the flowers give the picture a very different quality from one such as *Fulfilment* (page 54). It can also be read as a tribute to the Japanese arts which influenced not only Klimt but almost all of the forward-looking painting and craft work of the period.

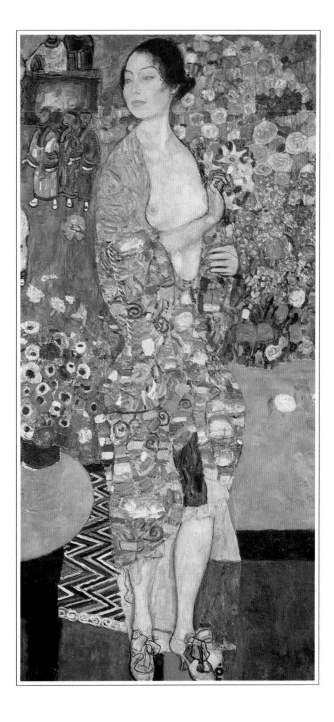

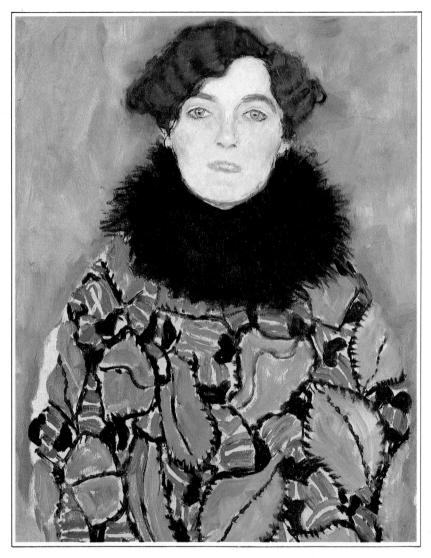

◁ **Portrait of
Johanna Staude** 1917-18

Oil on canvas

THIS SMALL, unusual portrait is
a reminder that when Klimt
died he was only 55, an age at
which many painters are still
capable of taking new
directions. Unlike Titian or
Goya, Klimt was denied the
chance of developing a 'late
manner'. The strong colours
he uses here create stark
contrasts reminiscent of the
French Fauves and German
Expressionists, although there
is nothing of their rawness of
emotion. Klimt has restrained
his decorative impulses so that,
despite the bold patterns of
Johanna Staude's coat, we are
most conscious of her face and
the personality it expresses;
unlike most of the women in
Klimt's late paintings, she is
grave, perhaps even sad. Her
short hair and general style
seem to foreshadow the post-
war world which Klimt would
never see; the portrait was left
unfinished at his death.

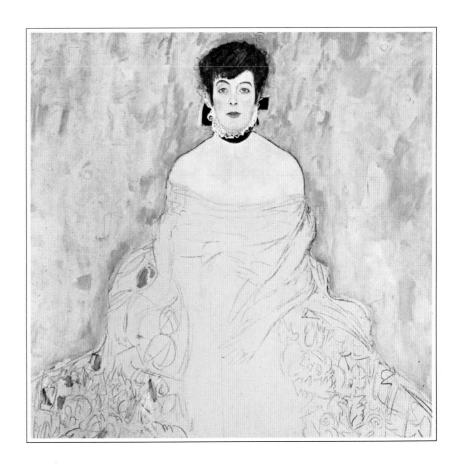

△ **Portrait of Amalie Zuckerkandl** 1917-18

Oil on canvas

EVEN WHEN HE WAS BEING denounced by the Viennese press as a pornographer, Klimt could command remarkably high prices for his portraits. This was just as well, since he worked very slowly and often returned to a painting and changed it, sometimes in fundamental ways. He seems to have had several projects on hand at any one time, as is clear from the fact that so many works were, like this one, left unfinished at his death. Amalie Zuckerkandl evidently posed in a ballgown whose splendours can be guessed at from Klimt's charcoal underdrawing – a reminder that the Viennese upper class continued to pursue their pleasures even in wartime. Amalie was the sister-in-law of the art critic Bertha Zuckerkandl, whose interviews with the normally reticent Klimt are of great interest. He also painted another member of the family, Paula Zuckerkandl, in 1912.

▷ **The Bride** 1917-18

Oil on canvas

The Bride APPEARS in a photograph of Klimt's studio taken in February 1918; along with the only other painting that is visible, *Lady with a Fan*, it was evidently being worked on at the actual time of the artist's death. Its unfinished state reveals the remarkable fact that Klimt painted the entire naked body of the figure on the right, including the exposed pubic area, before beginning to cover it up with painted clothing. Since the finish goes beyond anything required to create an underlying structure for the fabric, this was obviously a private ritual, performed for Klimt's secret erotic gratification. As in the near-contemporary *Adam and Eve* (page 78), a male face appears among Klimt's women for the first time in some years; doubtless the one here is the 'husband'. The Bride may well be a sequel to *The Virgin* (page 71), offering a similar variety of ecstatic states which have, presumably, reached the point of realization.

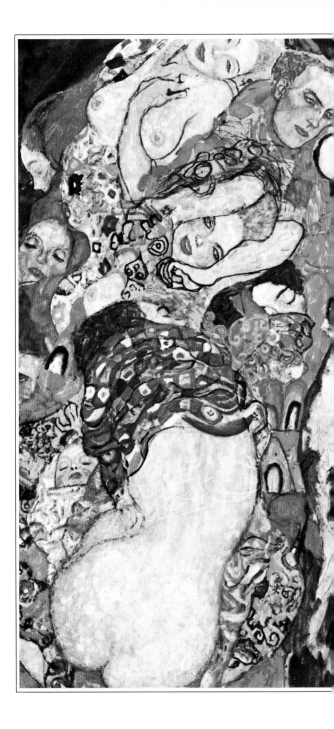

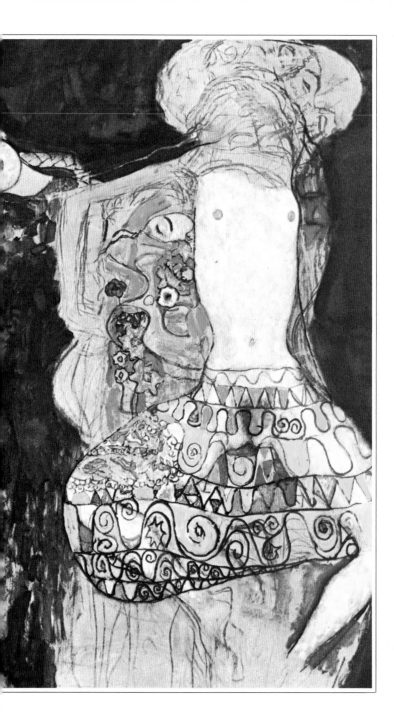

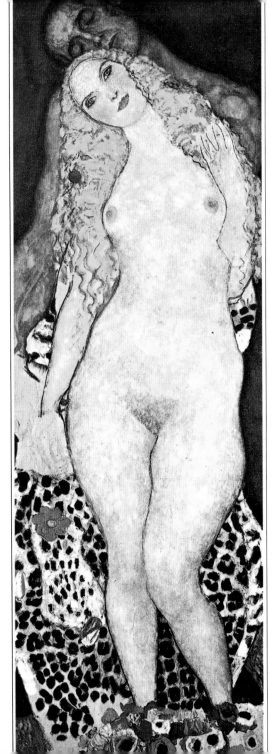

◁ **Adam and Eve** 1917-18

Oil on canvas

THIS IS ONE of several paintings, dating from the final year of Klimt's life, that were still in progress when he died on 6 February 1918; the unfinished state of Eve's hands is particularly obvious. The title is not very helpful in deciphering the relationship be tween the two figures. In most of his works Klimt took over the convention (found in Greek vase painting) of making the male darker than the female; but here their flesh tones are startlingly different, Eve's paleness emphasizing her primacy. Adam's position behind her is not unlike a ballet dancer's, but his expression is one of suffering or exhaustion. His closed eyes bring to mind the Holofernes heads in the two *Judith* paintings (pages 33 and 61), but it is unlikely that Klimt intended to portray Eve as a sensual man-breaker. Serenely fair, posed against a leopardskin with her feet in a mass of anemones, she is one of Klimt's most endearing and least troubling creations.

ACKNOWLEDGEMENTS

The Publisher would like to thank the following for their kind permission to reproduce the paintings in this book:

Archiv fur Kunst und Gershichte, Berlin 10-11, 15, 17, 19, 21, 26-27, 34-35, 36-37, 38-39, 40-41, 43, 44, 45, 54, 55, 57, 58, 59, 64-65, 67, 71, 72, 74, 76-77, 78;

Artothek, Peissenberg 49, 50; /**National Galerie, Prague** 60; /**Osterreichisches Galerie, Vienna** 63, 66;

Bridgeman Art Library, London /**Historiches Museum der Stadt, Vienna** 8-9, 12-13, 23, 42; /**Museum d'Arte Moderna, Venice** 61; /**Osterreichisches Galerie, Vienna** 25, 33, 46, 51, 53; /**Tiroler Landesmuseum Ferdinandeum, Innsbruck** 16; /**Private Collection** 18;

Galerie St. Etienne, New York 29, 32, 73;

Galerie Welz, Salzburg 30, 31, 68-69, 75.